W9-AFH-456

WITHDRAWN
No longer the property of the
Boston Public Library.
Sale of this material benefits the Library

TT504.6
.I8
C44
1998

First published in the United States of America in 1998
by **UNIVERSE PUBLISHING**
A Division of Rizzoli International Publications, Inc.
300 Park Avenue South
New York, NY 10010

and

THE VENDOME PRESS

© 1998 Éditions Assouline, Paris
English translation copyright © 1998 Universe Publishing

Front cover photograph: James Bond, played by Pierce Brosnan, wears Brioni hand-tailored clothing
in *GoldenEye* (1995) and *Tomorrow Never Dies* (1997)(Eon Productions and MFGM/UA Films).
© Brioni Archives.
Back cover photograph: Clark Gable trying on a suit in the Brioni workshop.
© Brioni Archives.

Text and captions translated by Cynthia Calder.

All rights reserved. No part of this publication may be reproduced, stored in a retrieval system, or
transmitted in any form or by any means, electronic, mechanical, photocopying, recording, or otherwise,
without prior consent of the publishers.

ISBN: 0-7893-02489

Printed and bound in France

Library of Congress Catalog Card Number: 98-60896

UNIVERSE OF FASHION

Brioni

BY FARID CHENOUNE

UNIVERSE / VENDOME

Foreword

In this century, the concept of "men's fashion" was practically invented in a small shop on Rome's Via Barberini. At the same time that Dior was creating the "New Look" for women in postwar Paris, the new Roman firm of Brioni began to challenge the hegemony of English menswear with a brighter palette, lighter fabrics, and less restrictive tailoring.

Brioni's postwar influence on the American dandy was cemented during the period when Rome became the center of the international film community, starting about the time of Roman Holiday *(1953). While Milan was still a fogbound satellite of British sartorial influence, Rome was embracing and refining the "continental look" pioneered by Brioni. Hollywood clotheshorses such as Gary Cooper, Clark Gable, and Rock Hudson made the pilgrimage to the Via Barberini and wore Brioni in places like Capri and Monte Carlo—or at least so we imagine, for cinematic fantasy and reality become intertwined and interdependent in this regard.*

Inspired by the mods and the rockers, London tailors and designers rejoined the battle for menswear supremacy during the sixties; but, looking back from this distance, it is safe to say that the Italians long ago won the war. After the baroque and rococo adventures of the sixties and seventies, Brioni has come to represent a new classicism—though the influence of their early innovations have broadened our definition of "classic" men's style today.

Even for those who have never heard the name, Brioni's interpretations of male finery, disseminated through movies and magazines, have become part of the collective international image bank—the uniform of the continental sophisticate. Today, devotees of the subtle luxury of Brioni are as likely to be heads of state, diplomats, and stylish CEOs as movie stars. Still, any male who has ever fantasized about being an international bon vivant aboard a yacht or in a convertible sportscar is probably picturing himself, whether he knows it or not, dressed in Brioni.

Jay McInerney

Brioni: The Birth of Italian Men's Fashion

"I'd have liked to pass for an Italian. I wanted to be chic."
HENRI CALET, *L'Italie à la parasseuse*, 1950.

"Rome is yours!" In May 1963 the magazine *Adam*, a long-established institution in the world of French elegance, urged its readers to indulge themselves in the Eternal City's frivolous delights, although Italy had made its debut on the stage of international men's fashion long before. Since the end of World War II, the news had spread like wildfire through cultivated circles on both sides of the Atlantic: on Europe's Mediterranean coast, which had languished in the shadow of London for over two hundred years, a different approach to menswear was flourishing—light, supple, colorful, easygoing, and daring. It wasn't long before there was a name for it—this fresh, new compass point on the map of masculine elegance was dubbed "Italian elegance."

The international success of Italian designers in the mid-seventies and eighties—the Giorgio Armani era—has erased from our memories the fifties' infatuation with that earlier elegance born on the banks of the Tiber. An infatuation indeed! Laid end to end, the praises sung in its honor by Western journalists—especially Americans—would have encircled the city of Rome. By 1956, touchy Parisian tailors, jealous of their rivals' clientele, were compelled to acknowledge, although somewhat lamely, the undeniable influence their colleagues and competitors had exercised across the Alps since the beginning of the decade.[1] Quite soon—between 1957 and 1962—there was nothing but Italian design in Paris. The shoes with the pointed toes were Italian; the stovepipe trousers were Italian; the cropped jackets with sloping shoulders worn by young members of the New Wave movement, and the tricksters, drag racers, and black shirts of the Algerian War generation, flaunted not only an Italian look, but a particularly Roman look.

"Fabrics for sale on the Via Baullari. These textile merchants drive all over Italy in trucks, organized in small teams, picking up supplies as the opportunity arises, buying inventory from bankrupt shops or actually selling stolen merchandise. The hawker gives his sales talk, growing more and more excited, working up to a climax with his final offer—four yards of this, two yards of that, then more of this one and that one, all for a price that is ridiculously low, promotional, that you'll never see again, practically nothing. And they buy miles of the stuff. Who's the dupe? Who's the con man? Promotions? Bankruptcy? Stolen goods? Nobody really wants to know. The purchase of fabric is certainly very important to the Roman man. So is presenting the 'bella figura'. For him, clothing comes before food."

WILLIAM KLEIN, *Roma*, 1959.

If you read the accounts of writers, journalists, and travelers who visited Italy after 1945, when the country had been cut off from tourism by some twenty years of fascism, you quickly grasp their fascination with the way men there dressed. "With their torsos slightly squeezed inside suits crafted from quality materials, wearing narrow low-fronted shoes with heels, the men cut fine figures in their white shirts and silk ties,"[2] wrote an admiring correspondent for *Le Monde* in 1952. "The Italians attach tremendous importance to their dress, at least to what they wear in the streets. They don't want to pass unnoticed. Men often wear colorful fabrics and pointed shoes with high insteps,"[3] continued another observer the following year. *Fare bella figura* is an expression that has become a cliché or a Neapolitan refrain to describe the taste for (or obsession with) one's clothes, the enchantment (or intoxication) with personal adornment, the pleasure (or ecstasy) of self display. This approach stood at crosscurrents with the self-effacing distinction of the British gentleman, who considered the Italian attraction to elegance a kind of emotional public obsession that climaxed during *la passegiata*, or the "promenade," in the open air theater of the streets.

Admirers of the peninsula's chic style consider "Italians worthy of their self-regard as the most elegant people in the world."[4] This pretension to elegance has aroused gibes, denunciations, and opposition. The fashion whims of the Italian male, with his penchant for tight cuts and his weakness for flashy fabrics, have undergone constant scrutiny by the narrow, yet reassuring measures of "good" and "bad" taste. Vulgarity, preciosity, conceited mannerisms, pretty-boy flirtatiousness, look-at-me chic, in-your-face new money: hostile pens did not lack for words to condemn this fashion, a heresy when judged by the elemental laws of masculine elegance as decreed by Brummel 150 years earlier (and seemingly forgotten). "Sporting the absolutely newest look, trying to imitate fashion magazine photos"[5]

—that's Italian elegance, concluded Jean-François Revel in 1958 during one of these assaults. Everyone had forgotten—or pretended to forget—the historical, cultural, and social context of this theatricality. However repressed, there was a setting for it in the pomp of the Mussolini era that galvanized Italy for over twenty years: parades, uniforms, jutting chins, and torsos bulging under black shirts. The style also fed on the narcissistic and fragile nature of Italian virility, caught up in a possessively matriarchal society. Brancati did a superb job of depicting this hidden male helplessness in his novel *Bell'Antonio*, in which the impotent seducer hero was acted on screen by Marcello Mastroianni. Finally, behind the tension between "good" and "bad" taste, there remained the stiff-necked resistance of an elitist society, bourgeois and reserved (in every sense of the word), to the vigorous growth of the contemporary culture of the "common man" with its "vulgar" (i.e., popular) elegance.

I taly was emerging from the war. Italians were victims of misery, especially in the South, where there was a mass exodus to major cities (as depicted in Visconti's 1960 film *Rocco and His Brothers*) and unemployment among young men. Arriving in Rome from the shanty towns on the city's outskirts, these boys were left entirely to their own devices, sleeping on benches in the Borghese gardens, not sure if they would wake up the next morning with their shoes still on their feet. They resembled the boy named Fabio who Pasolini meets in 1952; his entire wardrobe consisted of a sweater and a pair of pants that he washed in the Tiber, waiting for them to dry before resuming his *vita violenta*.[6] This setting must be understood in order to grasp the naive, vital longing of Italian men in the fifties to make themselves handsome, to carry themselves proudly

even if they didn't have enough to eat; they dealt with hunger as they dealt with women—by deploying the frivolous, arrogant weapons of elegance. Under their "brilliantly cool shirts" and "tenderly detailed and impeccably creased trousers" they hid their "empty bellies,"[7] like those nameless Roman comrades of the young hero in *Tempo di Roma*, Alexis Curvers's lavish and melancholy novel published in 1957. It was this "deep longing for something more"[8] (Pasolini again), that lent a resonance and intensity to the Italian elegance which burst upon the scene in the fifties.

> *"In Rome,...men's fashion is driven by two major forces— the climate and the influence of the American colony. The climate promotes exuberance, the Americans extravagance."*
> ENNIO FLAIANO, *L'Espresso-mese*, November 1960, *La Solitude du satyre*.

This compelling drive toward the superficial lies at the heart of Italy's metamorphosis during the period. It was the era of the famous "Italian economic miracle" which led to a revitalization of industry at the end of the decade in part of the peninsula. This provided some Italians access to the rituals and ephemeral splendors of modern consumerism. Italian design was in full flower, embracing routine objects of daily life, lending them form and style. This was the golden age of automobiles "made in Italy," of *pappagalli* on their Vespas (1946) in pursuit of a *donna* under the Eternal City's azure skies, of the little Fiat 500 (1956) which would be driven by millions of modest motorists, and of the fantasy car, the Testa Rossa. It was an era when Rome was the citadel of film, of Cinecittà, a hive abuzz with the activities of a bohemian array of producers and directors, actors and starlets, journalists and paparazzi: Cinecittà was the factory of dreams tinged with bitterness that produced *La Dolce Vita* in 1959, the film that mirrored this era when everything began

(usually well) and ended (often badly) on the Via Veneto.

It was in Rome that the atmosphere of this new Italy most brilliantly crystallized. Rome was the center of postwar cultural and recreational tourism. Roma, languorous and sensual, with its impoverished, decadent aristocracy (remember the madam in Tennessee Williams's *The Roman Spring of Mrs. Stone*), or the marquise in *Tempo di Roma* of 1957 and its proletariat substratum of young gigolos, allied to provide their services (sex and sophistication) to the ultra-wealthy Americans in search of a quick adventure. It was in Rome that male Italian elegance truly flourished, like one of the city's special flowers, in contrast to earnest Milan and austere Turin, which traditionally gave their allegiance to the orthodox sobriety of Anglo-Saxon style and to the mighty guardians of that tradition, the tailors of Savile Row. Rome was the first place where you could see "young men in striped silk jackets and other flourishes, worn with colonial pride," recounts Ennio Flaiano. "It might be fun for the idle playboy to design a striped silk jacket. . ." added the director of *La Strada, La Dolce Vita, 8-1/2,* and *Roma.* "But it becomes confusing when the same jacket is worn by a melancholy young man from around here, who doesn't want to be left out of the loop. Then all of a sudden popular magazines are showing stripes and they're being worn all over the suburbs. There's no other place where they pick up the latest fashions as fast as we do here." [9]

Once again the scene unfolds like a cliché. After a stroll among the ruins, and a snack of prosciutto and green figs in a little trattoria, the tourist pushes open the doors of the tempting boutiques on the Via Veneto or the Corso d'Italia, intoxicated by the feverish elegance of the streets. As soon as Henri Calet arrived in

Rome in 1950, he fell under its spell, treating himself to a made-to-order "two-piece summer suit."[10] Tourists "in-the-know" with money to spend had their poplin shirts made at Battistoni and bought their soft leather shoes at Francheschini, dropping the melodious names of their Italian tailors—Giuliano, Caraceni, Cifonelli, Litrico, Baratta, Datti—in selected conversations. Among all these names, one alone stood in the vanguard of Italian men's fashion: Brioni.

In the liberated Rome of 1945, Nazareno Fonticoli and Gaetano Savini opened their own boutique with its made-to-measure salon on the Via Barberini. They had worked together before at Satos on the Via del Corso. They named their shop "Brioni" after an island in the Adriatic Sea off Trieste, a gathering place of the sophisticated Italian elite in the inter-war period. The relationship between Nazareno Fonticoli and Gaetano Savini was unquestionably one of the keys to their success. Fonticoli, an inventive tailor, had learned to wield scissors and needle in Penne, his native town in Abruzzi, where a tradition of fine craftsmanship retained great vitality. Mountainous Abruzzi had already provided Italy with some of its most prestigious tailors: Ciro Giuliano, Caraceni, Imoberdorf, Del Rosso. Abruzzi legend has it that the region's sartorial calling (*sartore* is Italian for tailor) can be traced back to the turn of the century to a certain Paolo Tosti, a celebrated singer and composer who was popular in Edward VII's England. The well-heeled Tosti, dressed by the best tailors of Savile Row, sent his used clothes to his brothers and cousins back in his native village of Ortona. By taking these suits apart to discover the mysteries of their construction, the anonymous tailors of Abruzzi perfected their expertise. In the fifties, Italy boasted more tailors than France or England. The quality and continuity of this artistic tradition explains in large part the admiration of the era's tastemakers, who marveled at the fluidity of this craftsmanship, discovering that "Italian tailors are the best in the world."[11]

As for Gaetano Savini, he was renowned for the brio of his salesmanship, his soft touch in human relations, and his business sense. The founders of Brioni soon realized that opportunity lay in America, and after only one crucial encounter they were convinced. They met the Marchese Giovanbattista Giorgini, considered to be one of the founding fathers of modern Italian fashion, who freed these styles from their confining insularity to conquer the American market, a market yearned after by the entire European garment trade. In 1951, this elegant *condottiere* organized the first "Italian High Fashion Show" in Florence for journalists and buyers from the United States. In the wake of the show's success, the next year he suggested that Brioni design the attire for gallant chevaliers who would escort the women modeling the Italian fashions.

Captivated by the Roman designers' tuxedos, silk and shantung smoking jackets, and their array of colors, B. Altman & Co., the famous Fifth Avenue department store in New York, decided to display Brioni fashions in the store's window. Brioni's American career was launched. A few months later in July 1952—on its own this time—Brioni presented a complete collection in the famous Sala Bianca in Florence's Pitti Palace. This was considered the first fashion show in the history of menswear, at a time when the twin rituals of the catwalk and the annual collection were the exclusive domain of women's fashion.

I n 1954, Brioni crossed the Atlantic—and held their first show in New York. Thereafter, Brioni models (the word had rarely been applied to men) became a fixture on the catwalks of America and the rest of the world. There was even a fashion show on board an ocean liner in 1956 as it cruised the Naples–New York route. In all, there were 288 presentations between 1952 and 1977,

virtually one per month, a feat which took the flair of a visionary and the persistence of a promoter to accomplish at a time when there was nothing else of the kind in the "no man's land" of men's fashion. Providing wardrobes for the theater and Roman films helped spread the label's name; as did the calling cards personally addressed to luxury hotel patrons and the low prices for made-to-measure silk and flannel suits (approximately \$125 versus \$250 in America).[12] The boutique on Via Barberini became an obligatory stop on any Italian visit for American socialites, whether they were "men of the world" vacationing in Rome or Hollywood celebrities shooting a film in the Cinecittà studios: Henry Fonda, Clark Gable, John Wayne, Kirk Douglas, Rock Hudson, Anthony Quinn, Gary Cooper *e tutti quanti*. In November 1959, *Gentlemen's Quarterly* published a long article entitled "The Tailors of Rome" that summed up this infatuation in a single phrase: Brioni had become "the Americans' tailor."

flamboyance, extravagance, euphoria: menswear was finally liberated from the greyness and constraints imposed by the concept of classic elegance. The American press used flowery language to describe the Roman tailor's exploits. Brioni was described as: the inventor of the "New Look" for men (*New York Times*, September 1955), "Dior for men" (*Life*, October 1955), the leader of a "second Italian Renaissance" (*The Boston Herald*, October 1955), and even as "the world's foremost menswear designer, as controversial as Balenciaga in women's wear" (*Sir*, October 1958). New York was not entirely virgin territory when Brioni arrived. The enthusiasm aroused by the label had a past, a "pre-history" that warrants an explanation. Italian immigrants had a complex, underground influence, dating from the nineteenth century. Following the example of other immigrant populations, they saw

dress as a passport to integration, recognition, and social acceptance, particularly during the period between the wars. Tailors and their sons worked in the American ready-to-wear industry at the same time that Sicilian mafiosi cultivated elegance, like an eloquent passage, in strange contrast to *l'omertà*, the law of silence, the code of the underworld.

From the outset, Brioni was noted for the range and brilliance of their palette, the daring vividness of their color, exemplified in the bright red of their 1952 shantung tuxedo jacket. In 1957, Brioni designed an exclusive collection for the American manufacturer Hess in Allentown, Pennsylvania. The "Hess" Collection is emblematic of the Peacock Revolution, which raised Brioni's profile and foreshadowed the Swinging London of the sixties. The "Hess" Collection evening wear was ablaze, preening and flaunting itself with a myriad of mannerisms. There was a deep purple tuxedo jacket over a shirt with a little jabot, a pearl-colored dinner jacket over a double-breasted pink waistcoat and cobalt blue trousers, a cocktail suit in gold silk. Each of the silk outfits sported lapels in contrasting colors and turned-back cuffs, touches of Mediterranean excess which the "teddy boys," young working-class Englishmen, had been borrowing (to the point of outright dispossession) from the neo-Edwardian dandies of the British upper class.

Reviewing Brioni's collection, you will find traces of almost every earthquake and aftershock—in form and color—that had shaken the monolith of the male wardrobe since 1950: silk shirts with cravats in 1966, collarless jackets and caftan jackets with embroidered trim in the late sixties, not to mention a "pre-Muglerian" suit designed in 1954 for a contest on fashion in the year 2000. In 1955, the *Ordine Dorico* Collection (referred to as the "Columnar Look") started a new trend from the "bold look" of the postwar years (double-breasted suits, loose-fitting jackets, wide

pants with deep cuffs) and christened the silhouette of the second half of the decade, with its more closely fitting jackets and narrow, cuffless trousers.

t he creation of the company and its "Brioni Roman Style" label in 1960 marked a turning point. At a time when fashion was becoming a mass market phenomenon and Brioni's tailors in Rome were overwhelmed by orders, Brioni Roman Style made a bet on a marriage that tailors had only dreamt of, without believing it could ever happen: combining made-to-measure with mass production. The factory that would make this dream a reality was established in Penne, Nazareno Fonticoli's home-town. In Abruzzi today, with one thousand people at work compared to a dozen when it began, the production of a made-to-order suit entails more than 150 steps, requiring eighteen to thirty hours of work, with roughly half this time spent in hand-crafting: preparation, tacking, stitching, finishing, from cutting the fabric for each client to hand-sewing buttonholes, the whole process interspersed with more than forty pressings. In 1980, Brioni established its own tailoring school in Penne to perpetuate the heritage of craftsmanship in the ancient tailor's trade, assuring the continuity of the high quality that marked the company from its time of origin, and which conveys the Brioni label's image today.

Brioni has gradually distanced itself from the stylistic extravagances for which it was once known. Over the years, it has expanded its collection to encompass the full menswear range including shirts, ties, leisure and sports clothes. Brioni has acquired refinement and restraint and now embodies an international elegance. Today, the company makes clothing to measure for more than 25,000 clients all over the world, including such high-profile

individuals as monarchs, sultans, business leaders, theatrical figures, and heads of state, ranging from President Nelson Mandela to international opera star Luciano Pavarotti. All that remains of that original "vulgarity" is a faint accent, an offhand touch, a kind of studied *sprezzatura* or "nonchalance," as they like to call it on the Via Barberini. Abandoning any past envy for British reserve, this is an elegance that is easy to wear. Brioni was selected to dress Pierce Brosnan, the James Bond of *GoldenEye*, in 1995, and *Tomorrow Never Dies*, in 1997, following the strictures of traditional elegance embodied by Sean Connery in the early Bond films of the 1960s. What outcome could be more telling about Brioni's impressive journey to the forefront of style?

Bibliography

Brioni Cinquntíanni di stile nel mondo, catalogue of the exhibition held at the Corsini Palace in 1996 for the fiftieth anniversary of Brioni. Florence: Octavo, 1996.

GIORGETTI (Cristina) et al., *Brioni. Fifty Years of Style*. Florence: Octavo, 1995.

MALOSSI (Giannino), et al., *La regola estrosa. Centíanni di eleganza maschile italiana*. Milan: Electa, 1993.

Notes

1. *Adam-Tailleur*, March 1956.

2. *Le Monde*, July 2, 1952.

3. LECHAT (Paul), *Italie* (Paris: Le Seuil, 1954), page 34.

4. PLANTHOL (Jacques) and JAMAN (Claude), *Étude des marchés textiles, Italie 1958-1959, débouchés tissage*, a study prepared for the Cotton Association and the Italian Committee of Artificial and Synthetic Textiles, Paris, 1959.

5. REVEL (Jean-François) *Pour l'Italie* (Paris: Robert Laffont, 1958), page 17.

6. PASOLINI (Pier Paolo), *General Correspondence 1940-1975*, translated by René de Ceccatty (Paris: Gallimard, 1991), page 200.

7. CURVERS (Alexis), *Tempo di Roma* (1957) (Arles: Actes Sud, 1991), page 131.

8. PASOLINI (Pier Paolo), *La Religione del mio tempo* (1961) in Piesies 1953-1956, translated by José Guidi (Paris: Gallimard, 1980), page 129.

9. *L'Espresso-mese*, November 1960, excerpt from *La Solitude du satyre*, translated by Brigitte Pérol, (Paris: Le Promeneur, 1990), page 157.

10. CALET (Henri), *L'Italie à la parasseuse* (1950) (Paris: Le Dilettante, 1990), page 143.

11. REVEL (Jean-François), *op. cit.*

12. GREEN, (Robert L.) "Profile—Brioni of Rome," *Town and Country*, August 1957.

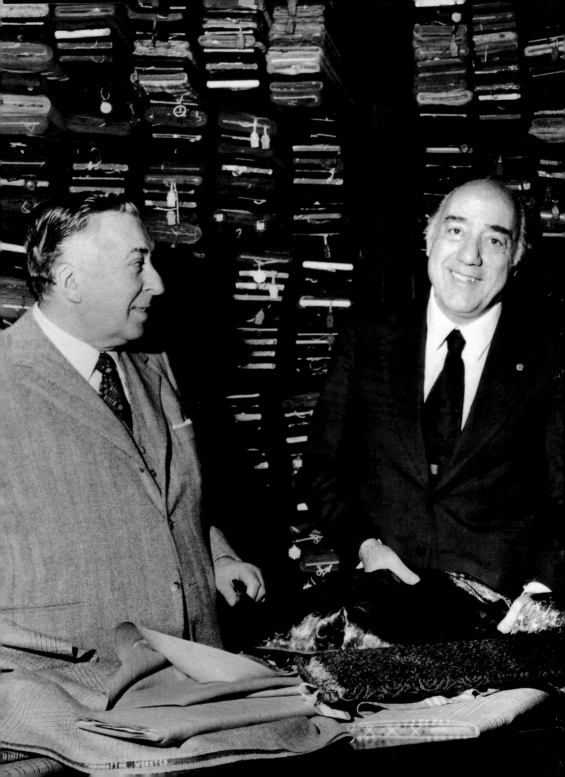

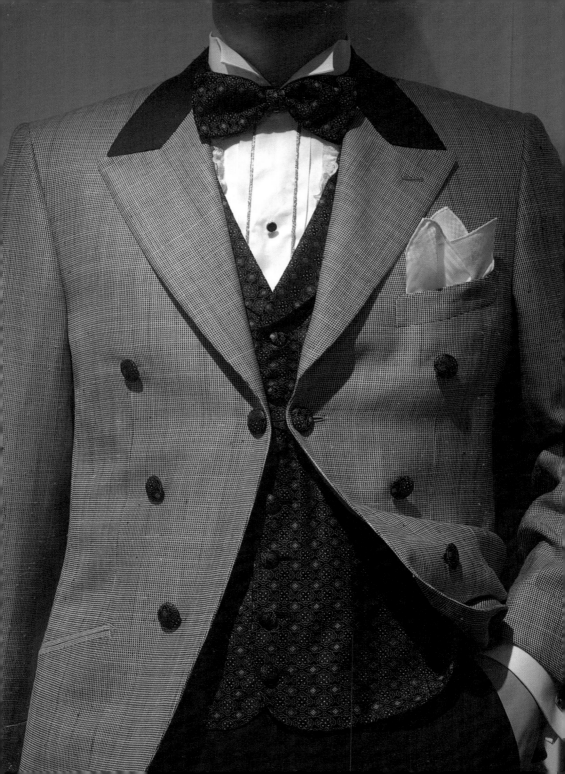

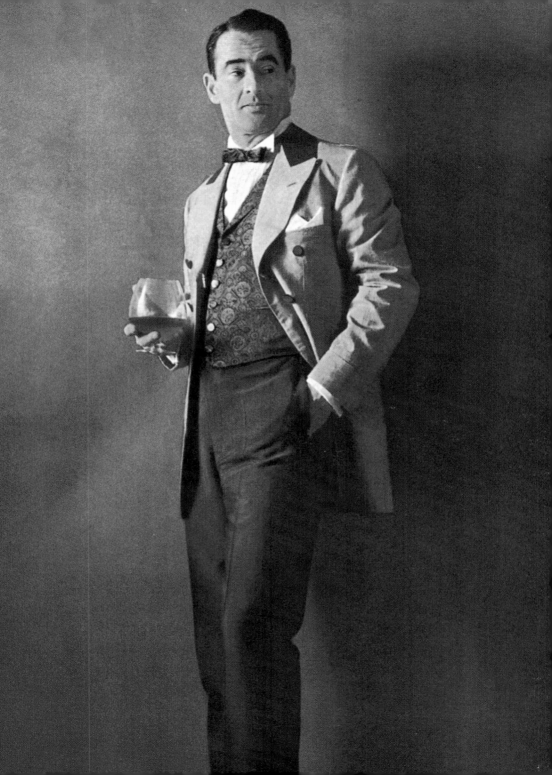

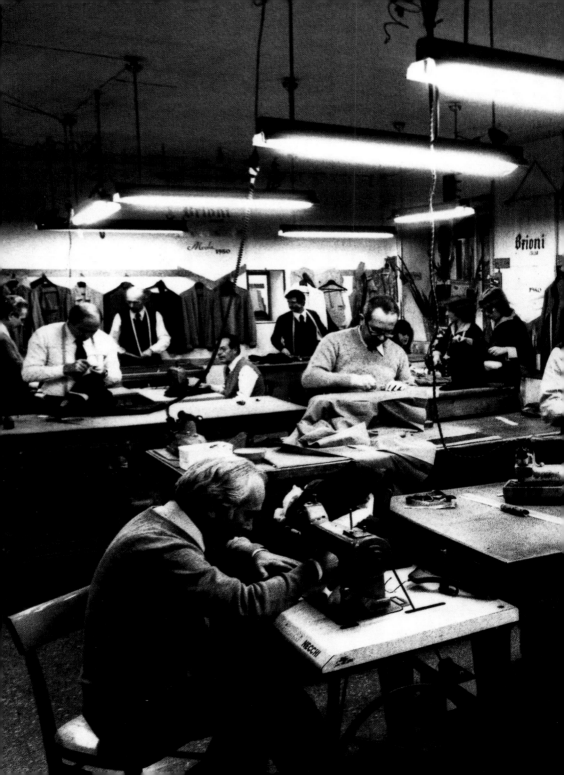

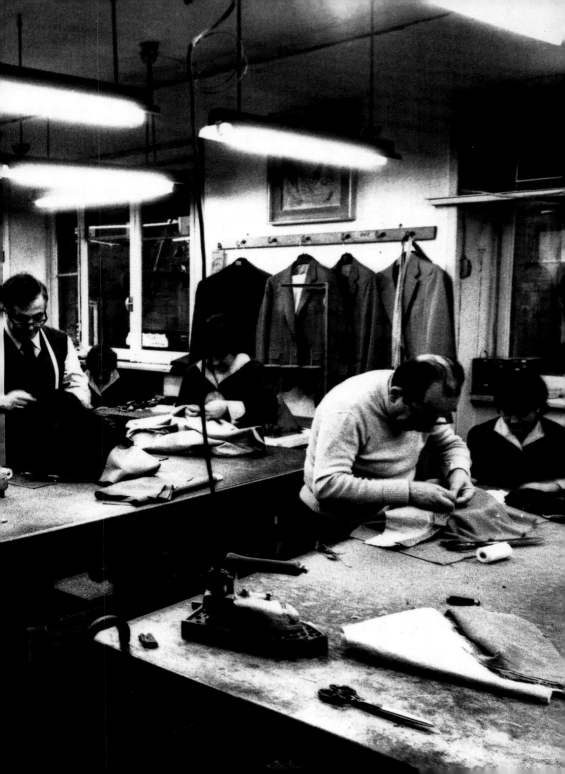

"LL'AMICO SANINI,
"ONA FORTUNA "BRIONI"!

Galeazo
Benti

Marco Cartellini

APRILE 950

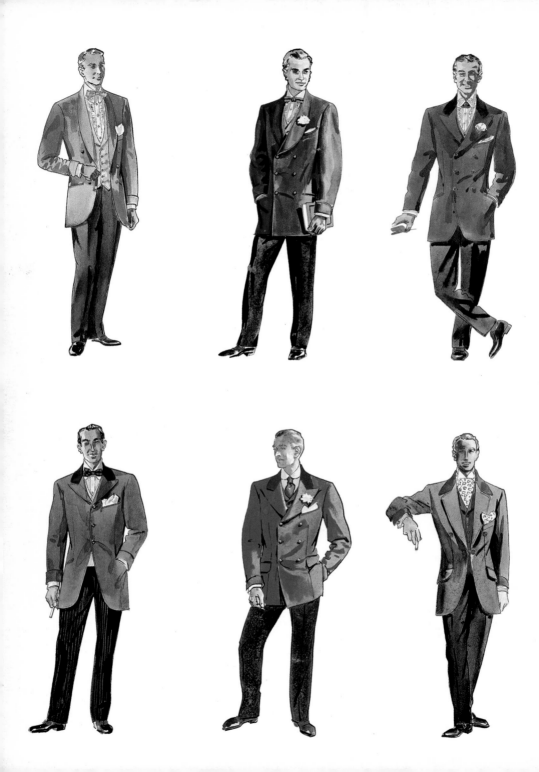

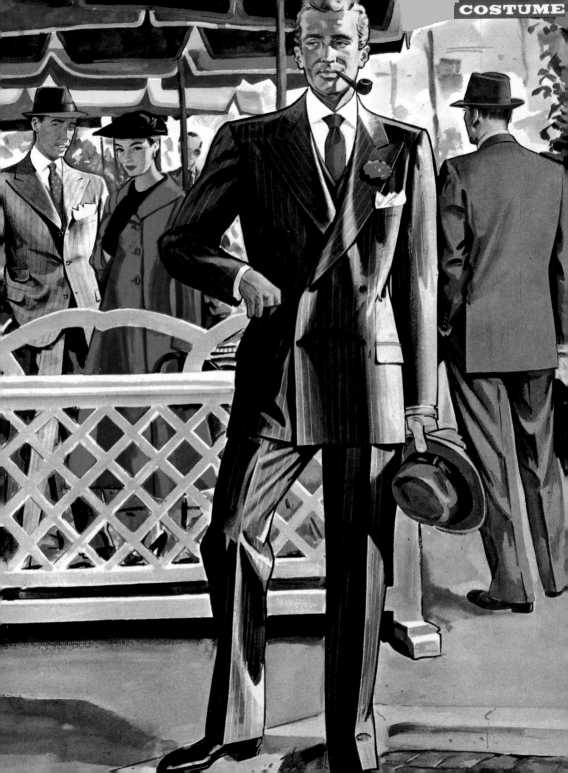

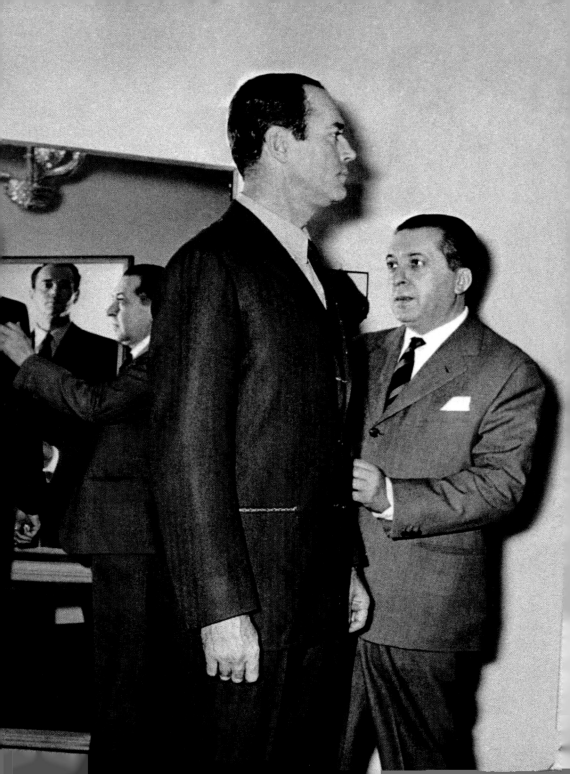

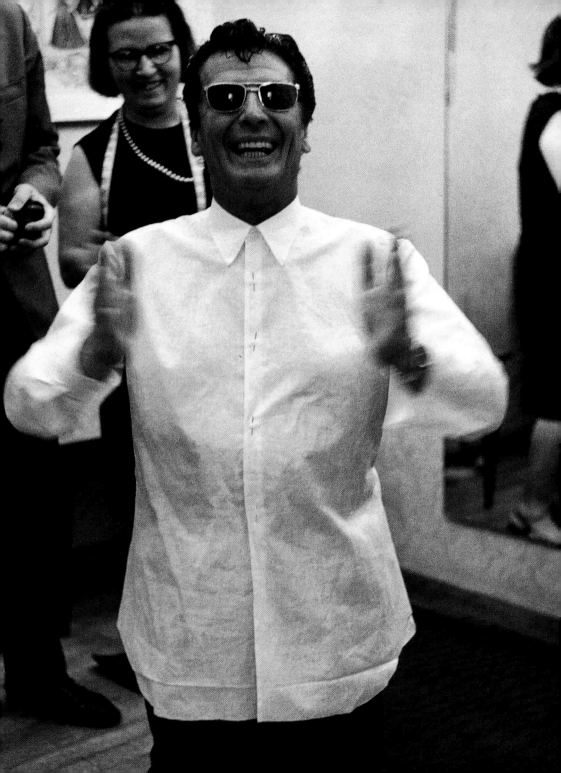

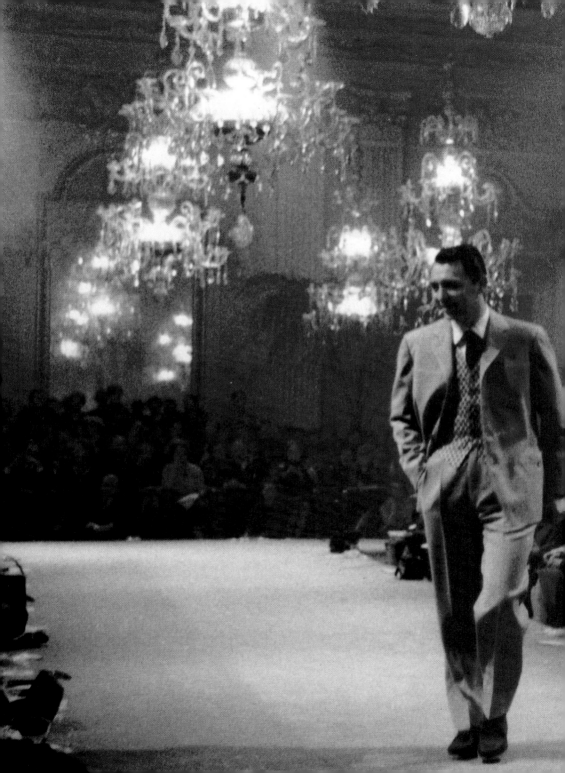

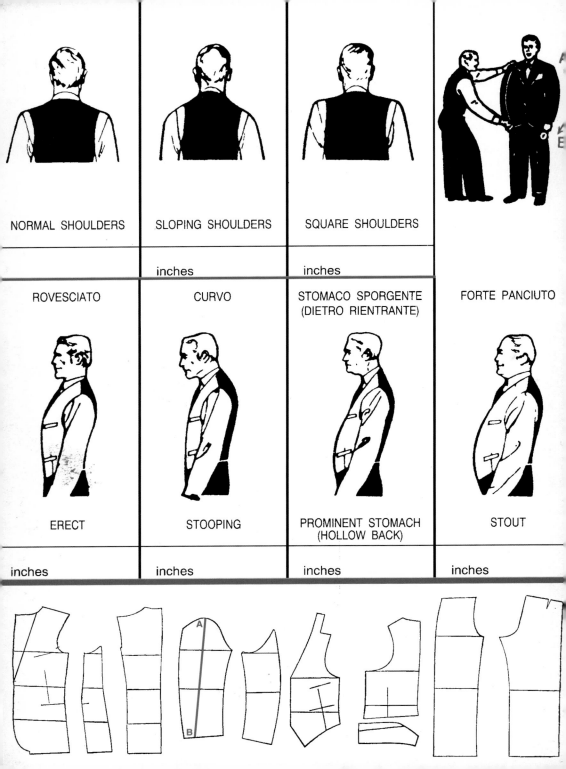

NORMAL SHOULDERS	SLOPING SHOULDERS	SQUARE SHOULDERS	
	inches	inches	
ROVESCIATO	CURVO	STOMACO SPORGENTE (DIETRO RIENTRANTE)	FORTE PANCIUTO
ERECT	STOOPING	PROMINENT STOMACH (HOLLOW BACK)	STOUT
inches	inches	inches	inches

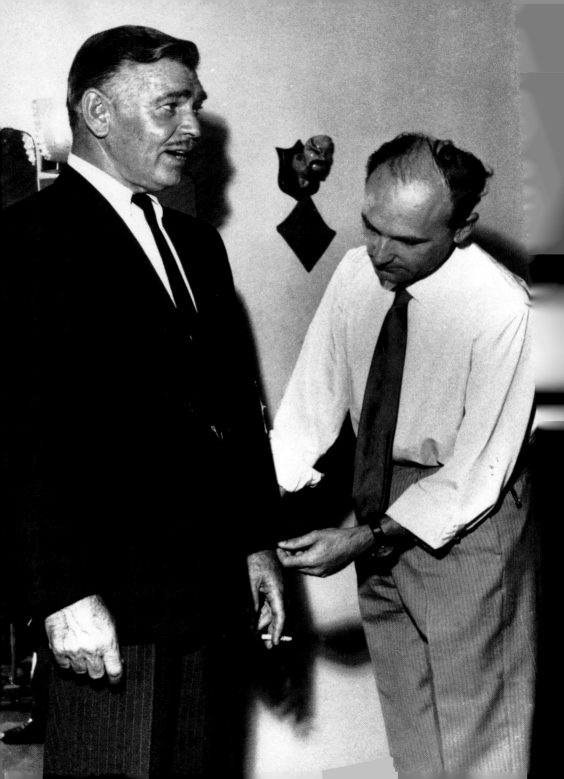

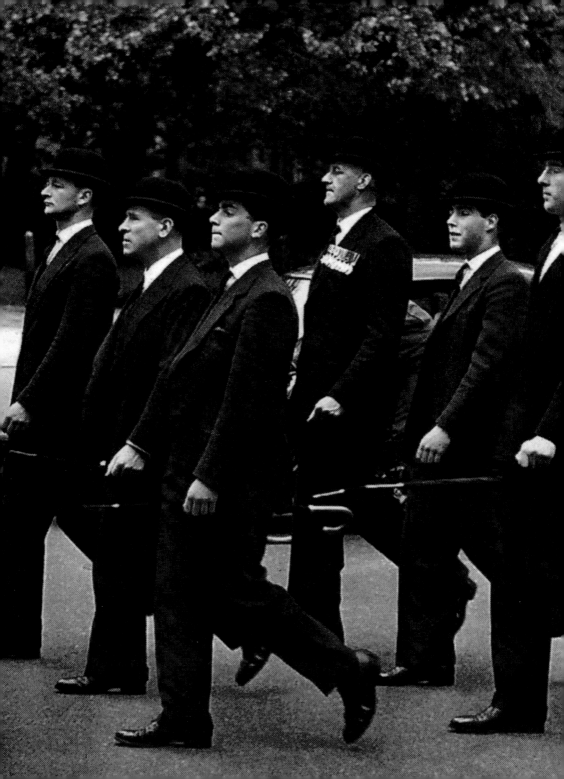

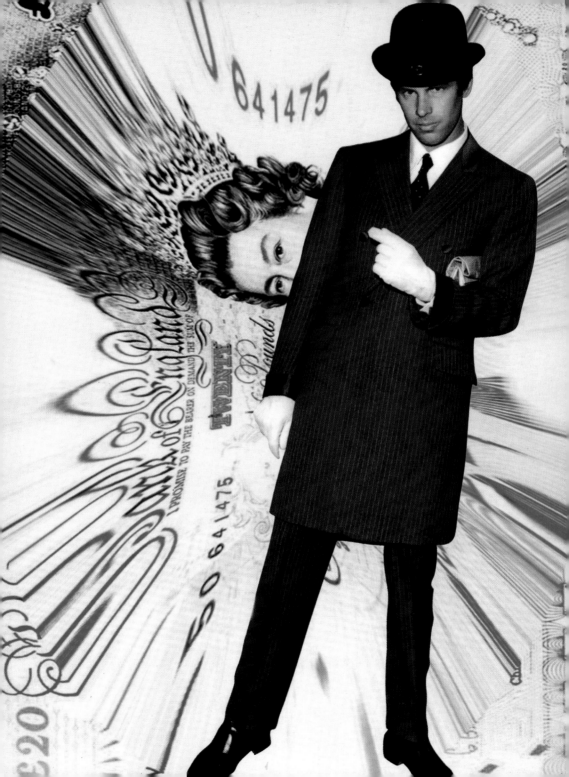

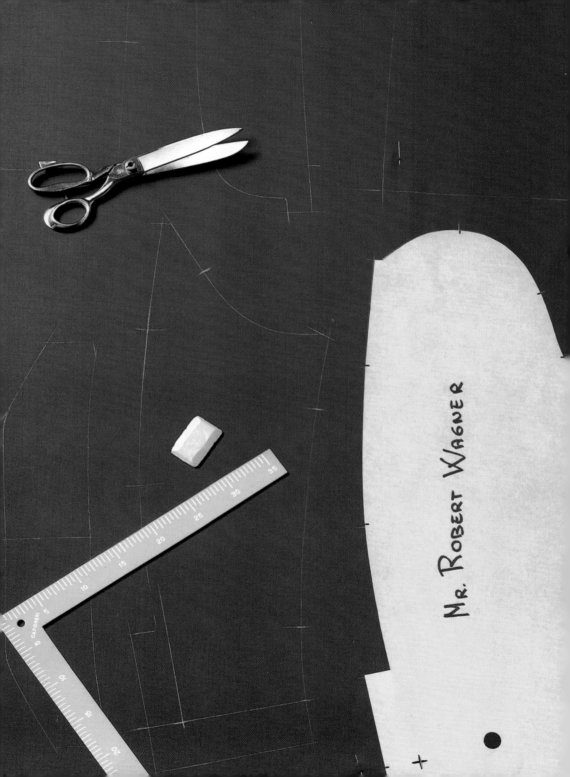

Mr. Robert Wagner

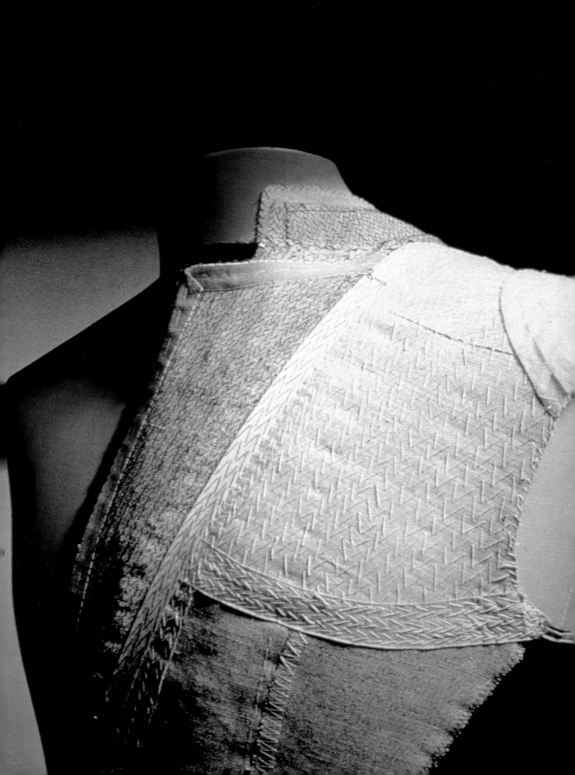

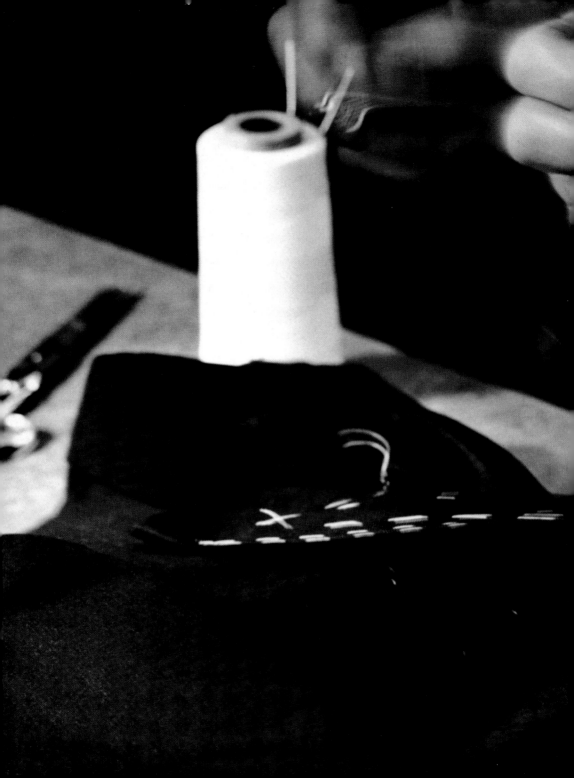

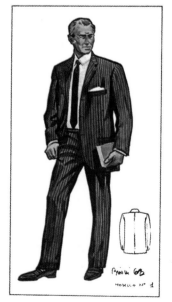

Cabana coordinate, Husky, miniature notched collar, 4-button closure. Multi-pocketed shorts squared at waist and leg line.

Jacket shirt, self-belted at natural waist line. Dyed-to-match buttons. Ribbed Gondolin trousers, frontier pockets, jacket fabric on cuffs.

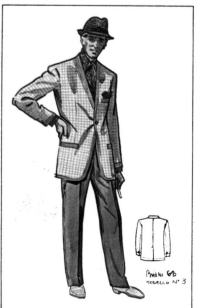

Riding Coat blazer. Single button closure. Extra long. Side-vented. Hand stitched outline of binding.

Checked blazer coat. Color-coordinated and trimmed in trouser fabric. Shirt fabric repeated in hat band and pocket square.

Shaped waist Suit, Cravat repeated in lining.

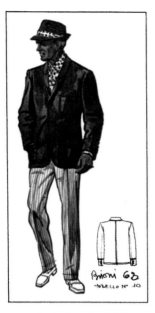

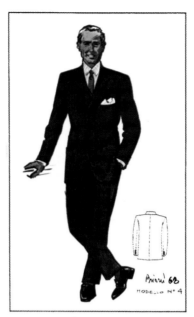

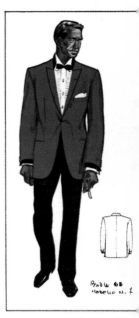

Shawl-collared blazer. 3-button closure. (worn all buttoned). Lively jacket lining. Tailored sportshirt, matched hat band.

Stretch flannel fly-front business suit. Broader notched lapels. Pink check business shirt.

The Veneto Dinner Coat. Stand-up black velvet collar, semi-cuffed. Newsworthy: subtlest glen plaid for dinner trousers.

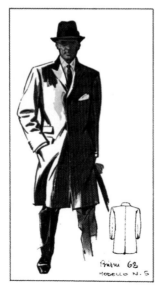

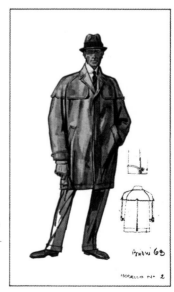

Suit-weight 40° topcoat. Shaped waist. Velvet collar. Multi-color cravat lining.

Split-cap news in treatm Demi-cuf Wide hem back que fly from

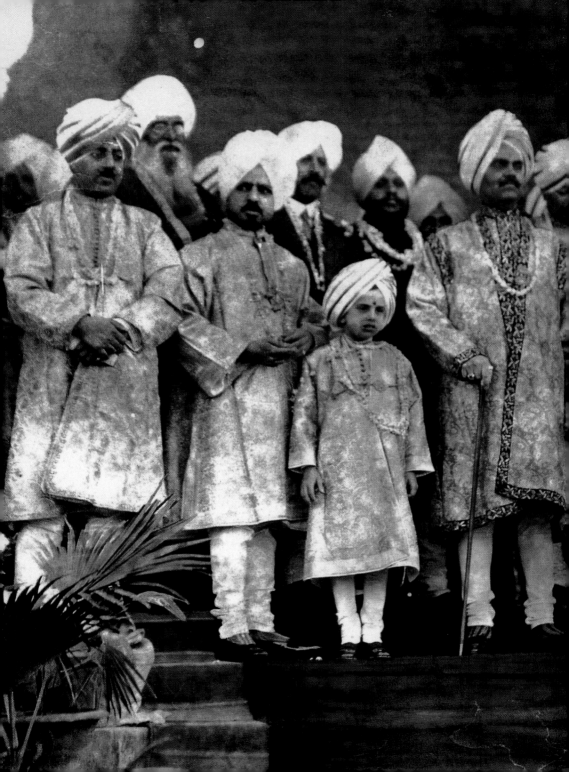

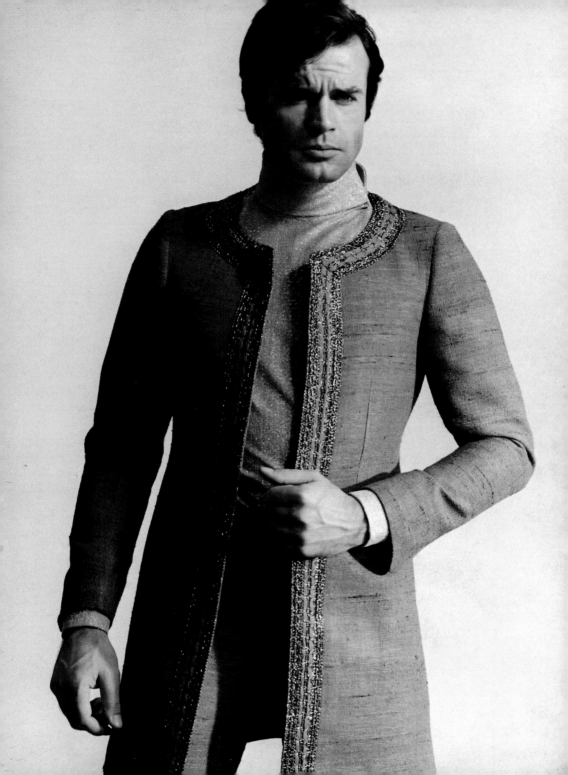

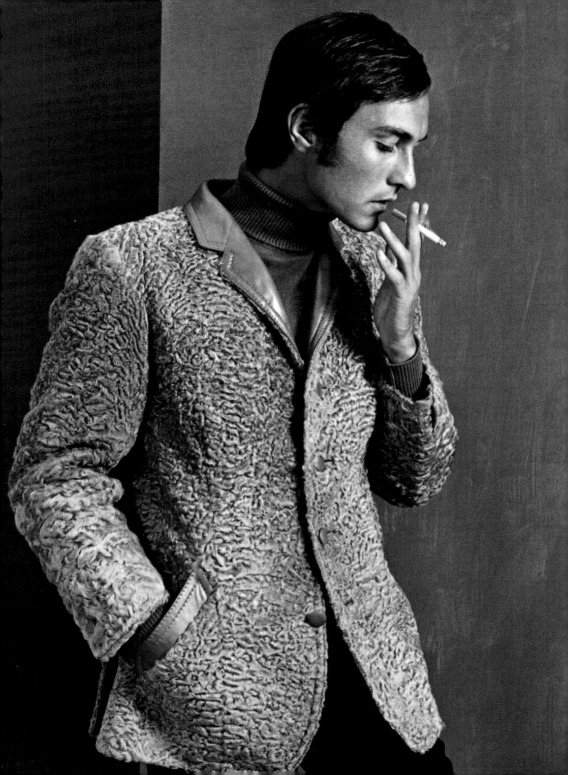

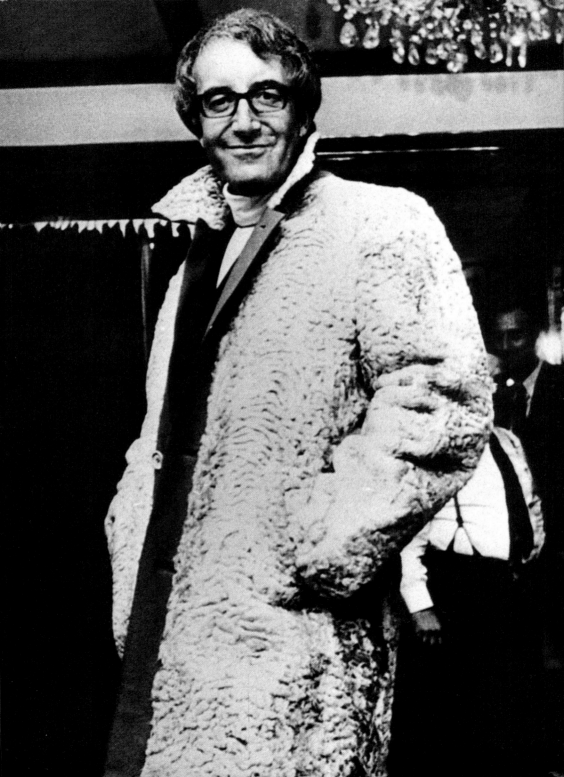

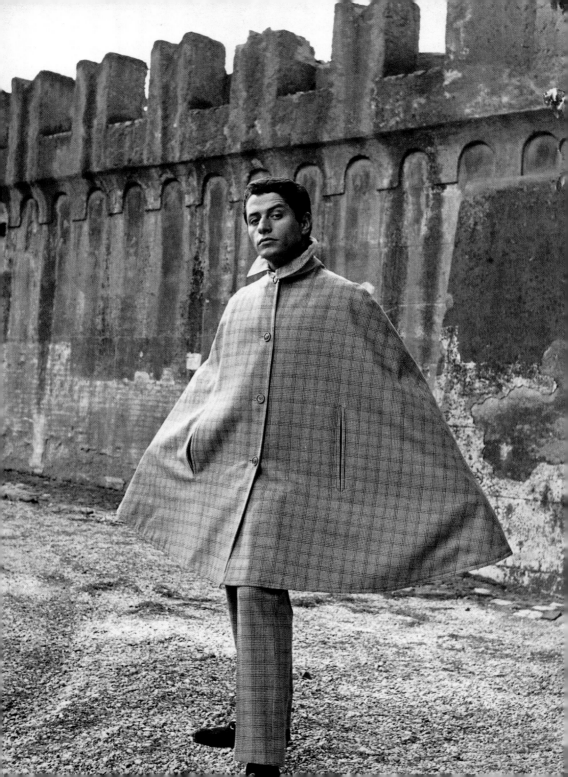

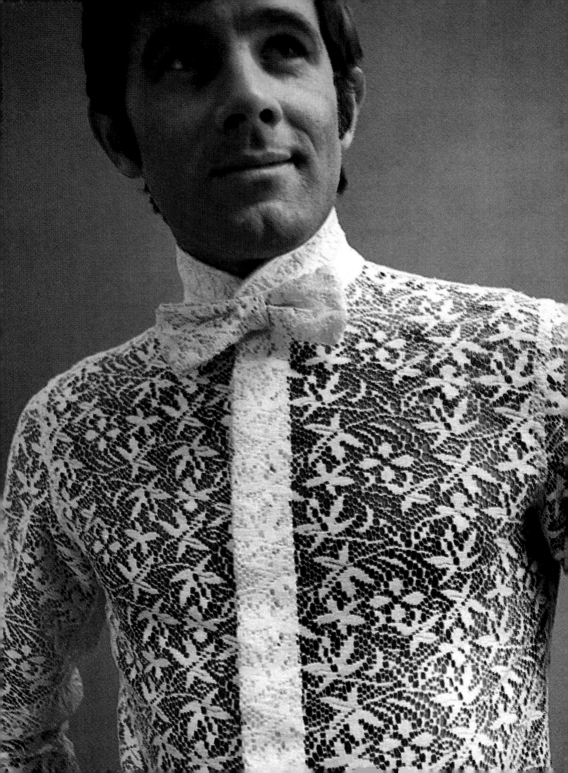

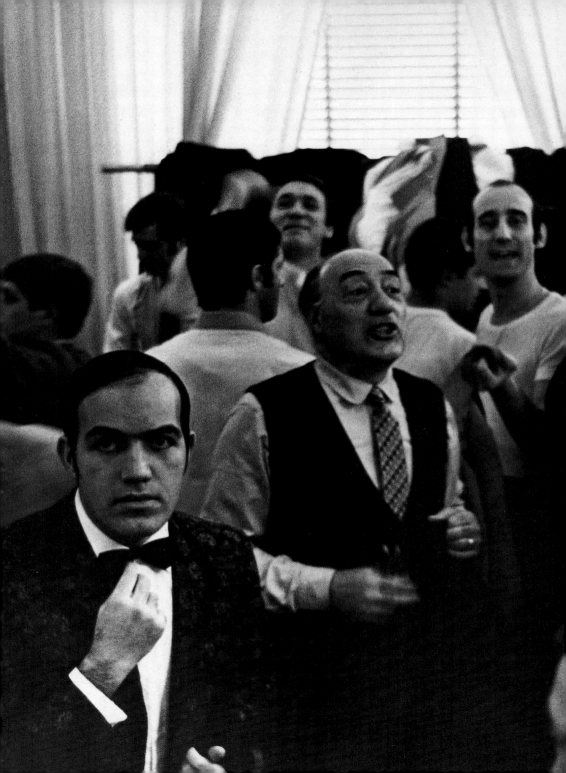

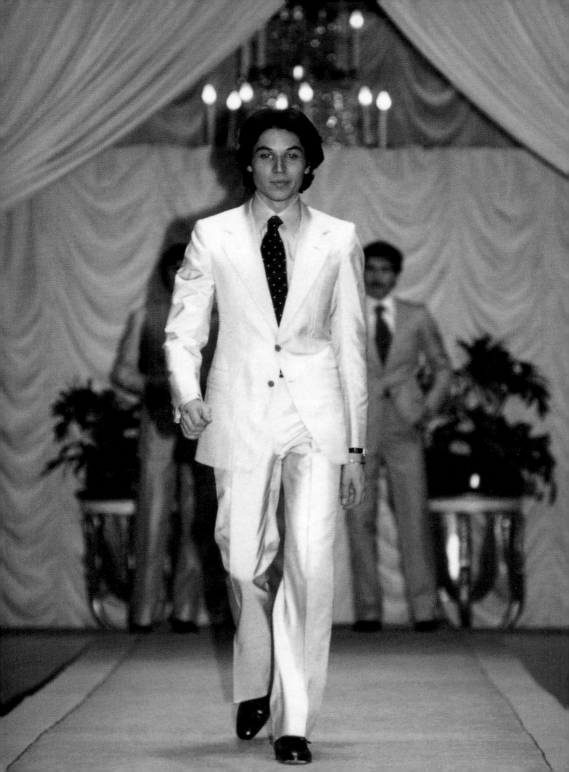

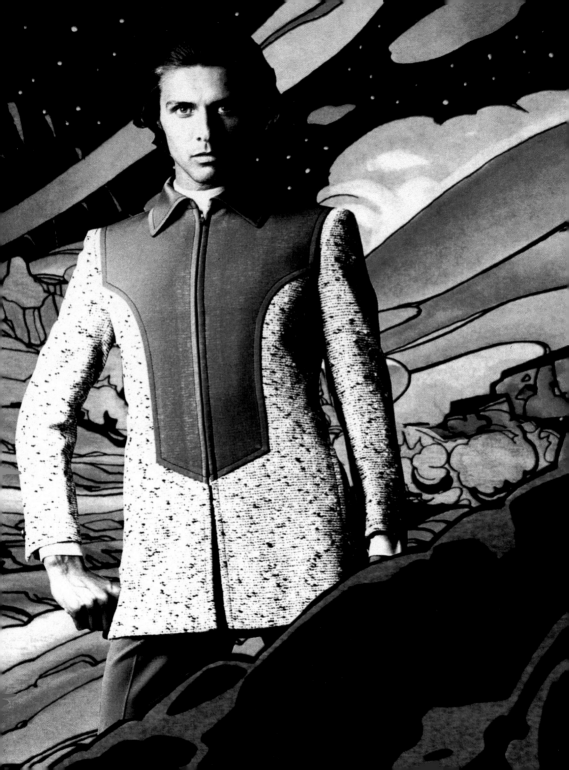

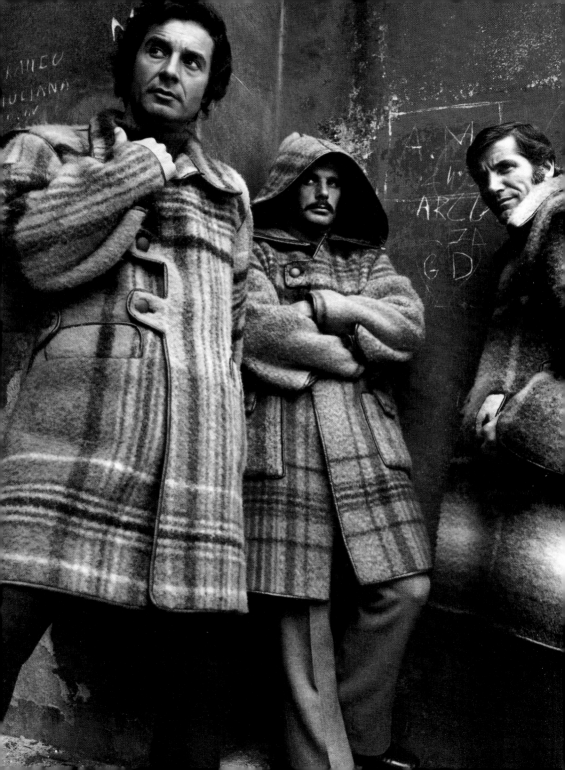

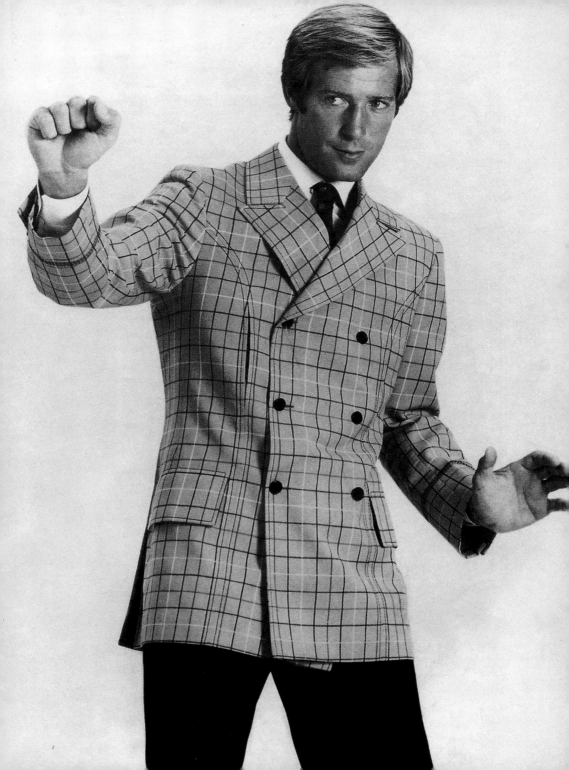

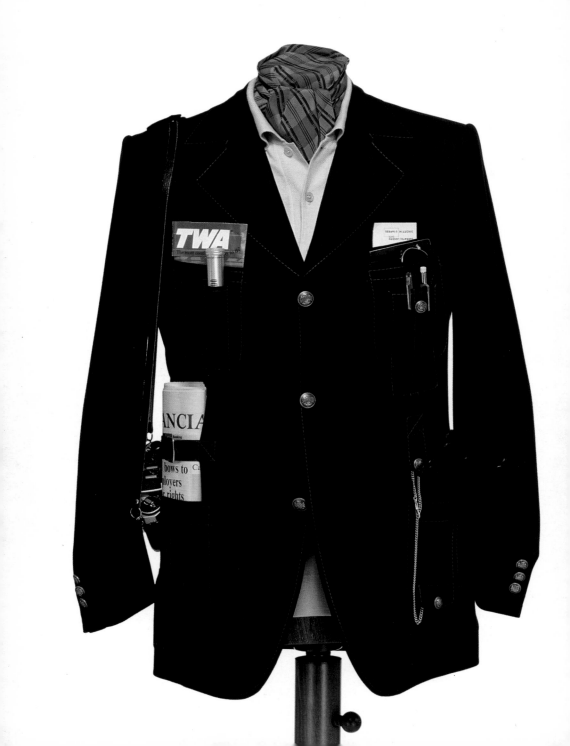

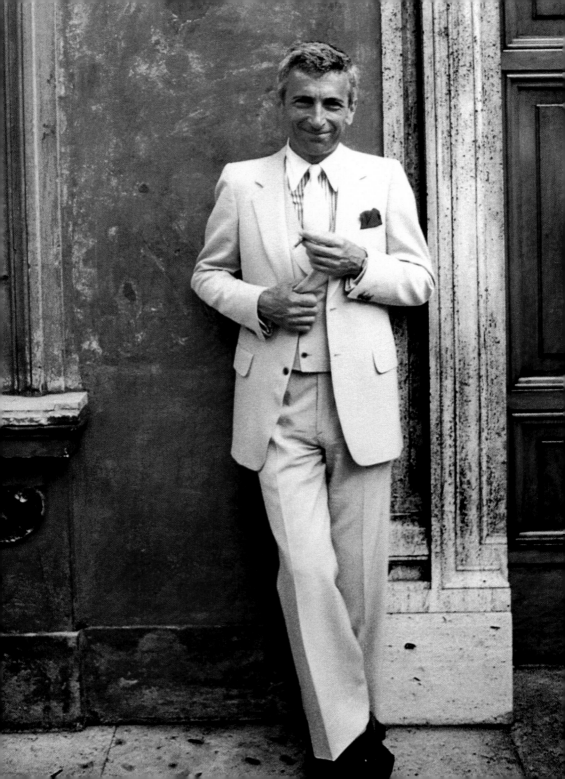

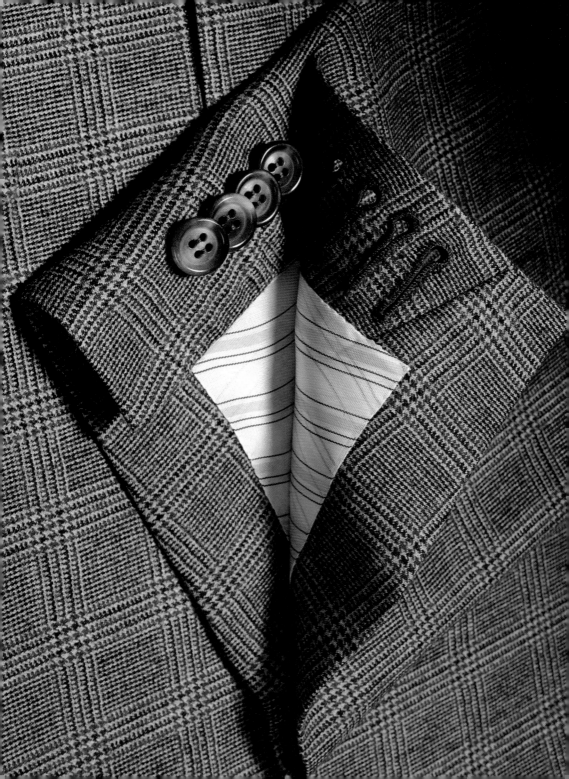

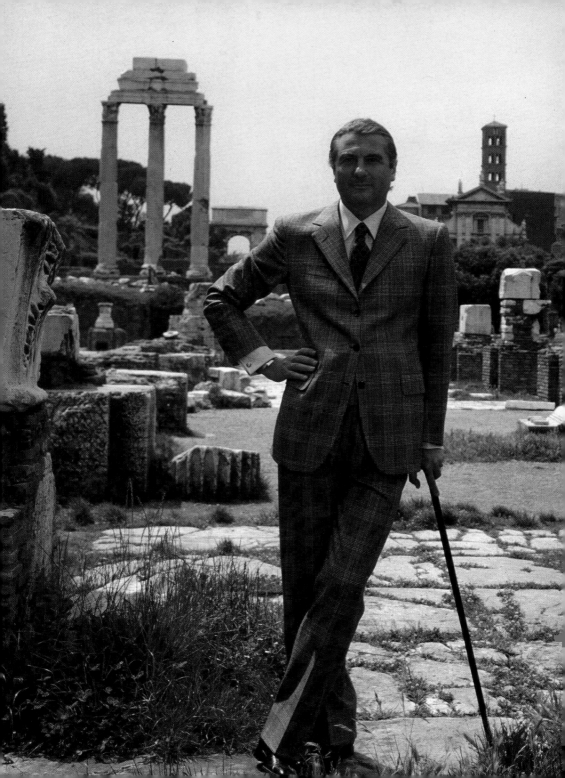

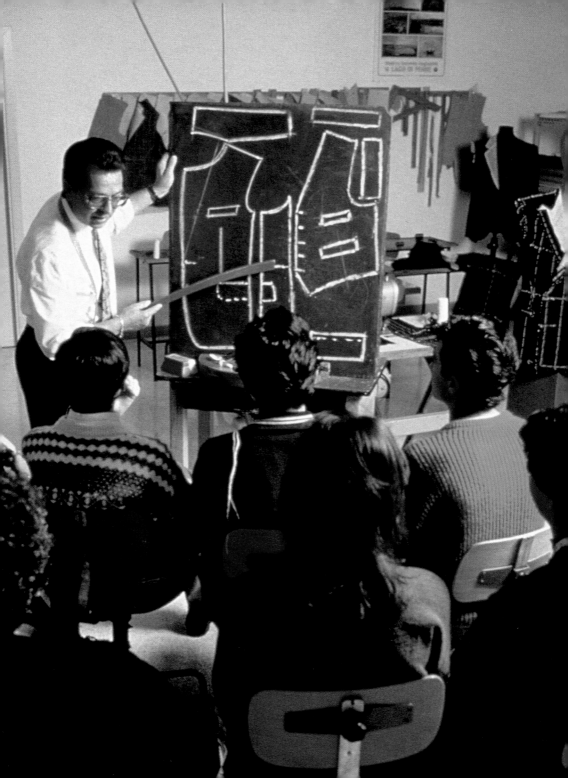

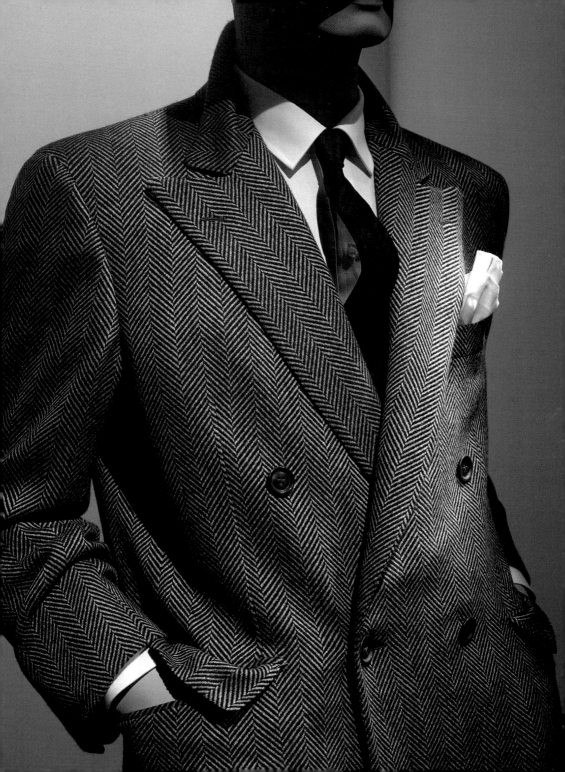

Men's
Couture

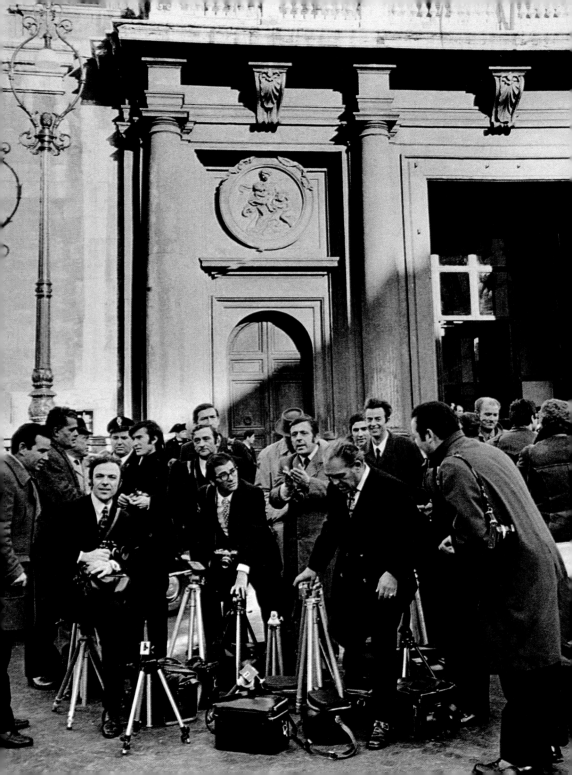

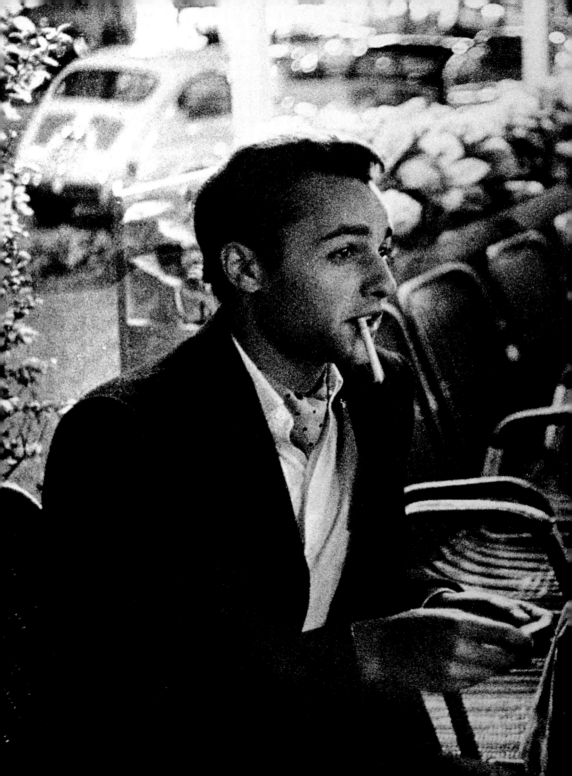

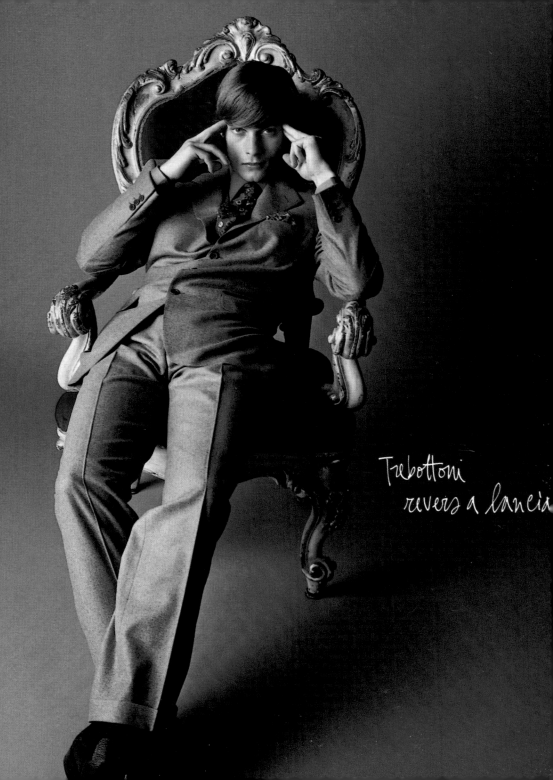

Trebottoni
revers a lancia

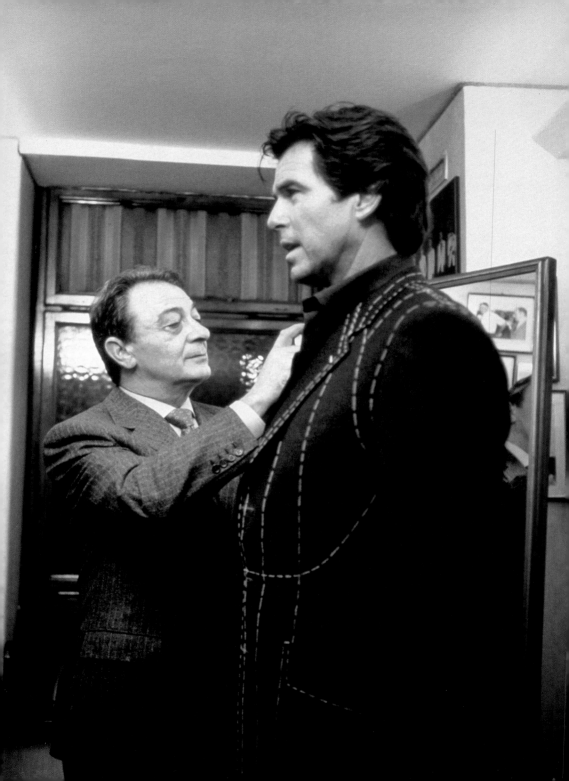

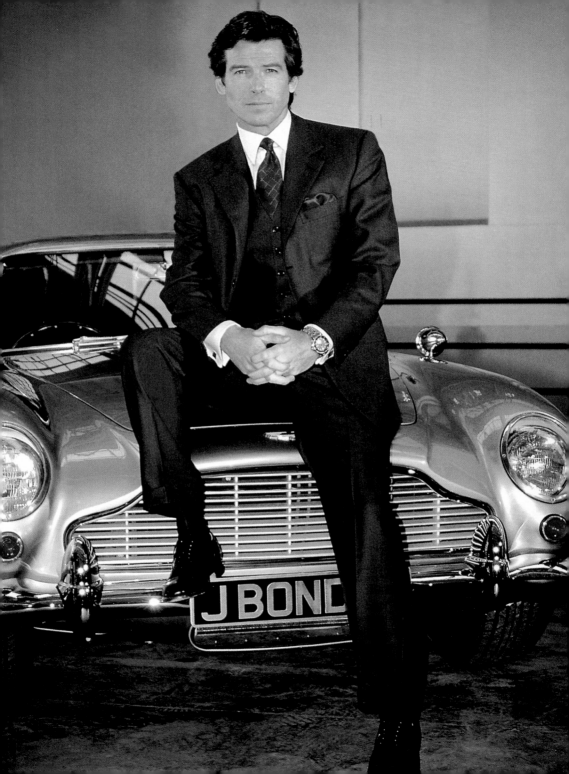

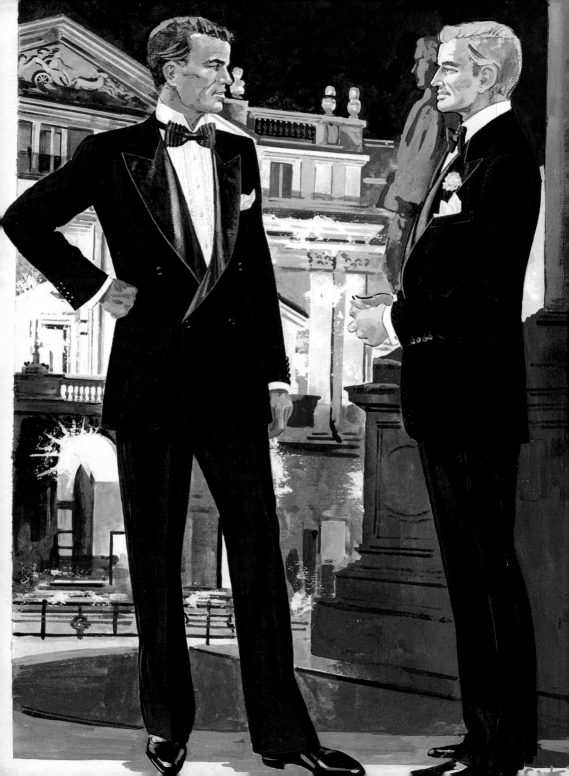

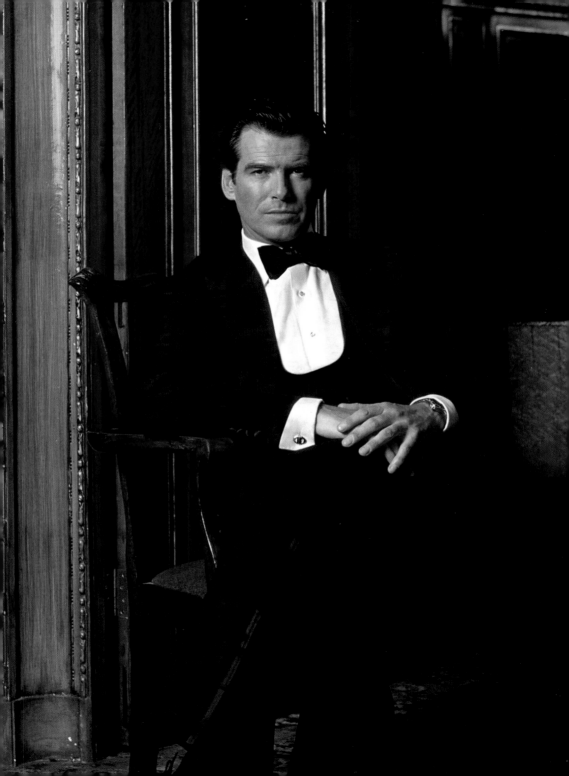

Brioni
1956

Chronology

1945: Nazareno Fonticoli, a master tailor from the Abruzzi region of Italy, teams up with Gaetano Savini, a Roman with a flair for design, to open a shop on the Via Barberini in Rome. They name the business "Atelier Brioni" after an island resort in the Adriatic where wealthy Europeans played polo and golf in the twenties and thirties.

1952: Brioni becomes the first men's company invited to show a complete collection of men's fashions on the runways at the Sala Bianca in Florence's Pitti Palace.

1954: Brioni stages its first men's runway fashion show in New York a year later with a new runway collection shown in eight cities including Boston, Chicago, and Los Angeles, and is acclaimed by *Life* magazine as the new "Men's Dior."

1956: The first men's fashion show on the high seas, aboard the S.S. *Cristoforo Columbo* sailing from Naples to New York.

1959: Brioni stages its first men's showing in London.

This same year, *Esquire* magazine honors Brioni with a special award for the company's "Valued Contribution to Menswear," and *Gentleman's Quarterly* bestows its prestigious Caswell Massey Award upon Brioni for "Excellence in Design of Formalwear, Sportswear, and Accessories for Gentleman," an honor it is to receive for the next seven consecutive years.

1960: To keep pace with the growing demand for their tailored clothing, Brioni establishes a separate manufacturing company, in Penne, Mr. Fonticoli's hometown. The system that he invented—tailors' workshops organized on industrial lines—is unique to this day.

1962: The International Fashion Council bestows its annual award upon Brioni for "Outstanding Contribution to the Fame and Glorious Reputation of Roman Styling."

1971: Brioni stages the first men's fashion show in the air, on a Philippines Airlines flight from Manila to Tokyo.

1977: Twenty-five years after Brioni's first fashion show, the company has already put on nearly three hundred shows in forty countries on five continents.

1980: The Penne factory establishes its own tailoring school to ensure a steady flow of expertly trained craftsmen and to preserve the hand-tailoring traditions which had been handed down through the generations. Graduates of the Scuola Superiore di Sartoria must complete a four-year course to become fully qualified tailors.

Drawing by Luigi Tarquini showing a printed lined coat and waistcoat, characteristic of the "Columnar Look"
launched by Brioni in 1955. © Brioni Archives.

1982: The first Brioni store in the United States opens in New York City's Park Avenue Plaza. By this time the company's products are already represented in over fifty of the world's most exclusive men's stores.

1983: Brioni is chosen to exhibit its early designs as part of the exhibition, "40 Years of Italian Fashion," held in New York.

1984: Brioni is again chosen to display in the "Moda Italiana 1920-1980" retrospective exhibition held in Tokyo.

1988: The prestigious "Premio Pitti" is given to Brioni for the company's contribution to the development of Italian fashion.

1990: Brioni commences a five-year expansion program to establish a high quality "total look." It acquires a series of leading manufacturers in related products to form the Brioni Group. In addition, a new factory is built to produce "Brioni Sport," a collection of luxury weekend clothes.

1992: Brioni designs from the 1950s are included in the "Birth of Italian Fashion," a retrospective exhibition organized by the Pitti Uomo and held at the Strozzi Palace in Florence.

1995 Brioni celebrates its Fiftieth Anniversary year with a major retrospective exhibition, fashion show, and gala dinner at the Palazzo Corsini in Florence.

Brioni is chosen to design and tailor the wardrobe for Pierce Brosnan as the new James Bond in *GoldenEye*.

1997: Brioni is chosen to design the costumes (tuxedos and dinner jackets) for the Broadway musical *Dream*.

Brioni is again chosen to dress Pierce Brosnan as James Bond in *Tomorrow Never Dies*.

John Wayne and Gaetano Savini in the Brioni workshop.
© *Brioni Archives.*

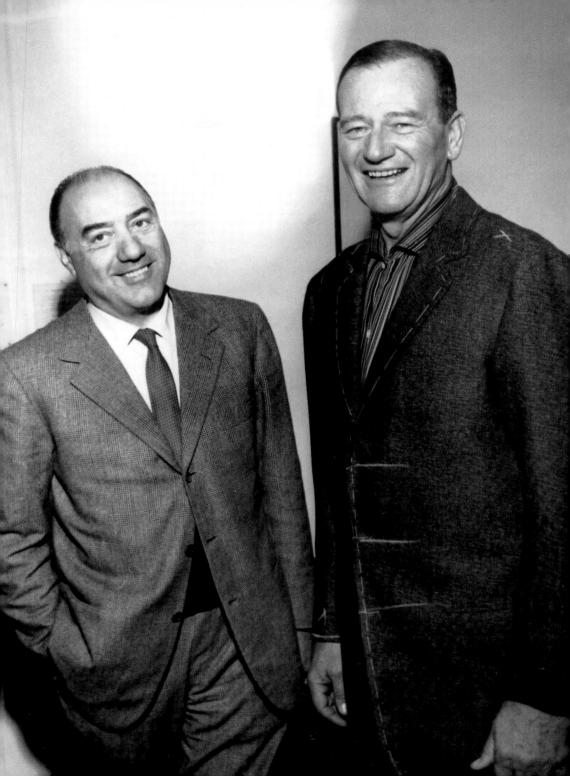

Brioni

Nazareno Fonticoli and Gaetano Savini, founders of the Brioni Studio in 1945. © Brioni Archives.
The Tailors of Rome, a drawing that appeared in *Gentlemen's Quarterly*, November 1959. © *Gentlemen's Quarterly*/Brioni Archives.

Pure silk dinner suit for the "Hess" Collection (1957). © Brioni Archives.
Tintoret design, "Hess" Collection (1957). © Brioni Archives.

Tailors working in the Rome workshops in the 1960s.
© Brioni Archives.

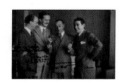

The Italian actors Mario Castellani, Galeazzo Benti, Toto and Bruno Ferri, who considered Brioni the epitome of menswear elegance (1950). © Brioni Archives.

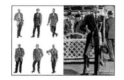

Drawings by Luigi Tarquini for the "Hess" Collection (1957). The colors for these silk outfits were inspired by the great Italian painters—Giorgione, Bernini, Giotto, Veronese. © Brioni Archives.
Drawing by Luigi Tarquini for the 1956 spring–summer collection.
© Brioni Archives.

Ready-to-wear designs by Brioni for men, presented at the Waldorf Astoria during the World's Fair in New York in 1964.
© Brioni Archives, photo: Edward Dzern, New York.

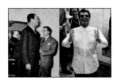

Henry Fonda with Nazareno Fonticoli, one of the founders of Brioni, in the Rome shop. © Brioni Archives.
Victor Mature trying on a Brioni shirt. © Brioni Archives.

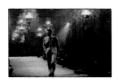

Fashion show held in the Sala Bianca in the Pitti Palace in Florence (1952). Brioni is the first menswear fashion house invited to present its collection on a runway. © Brioni Archives.

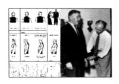

Details of drawings from the order forms used by the Made-to-Measure department, showing the different shoulder styles available for a certain jacket design. © Brioni Archives.
Clark Gable trying on a suit in the Brioni workshop (1950s). © Brioni Archives.

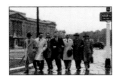

Gaetano Savini with his team, in London for the Brioni show at the Hyde Park Hotel (1959). © Brioni Archives/United Press Photos, London.

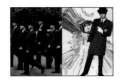

In the 1960s, Brioni was inspired by traditional London designs: dark suits, bowler hats, black patent leather shoes, and umbrellas. Shown here are officers of the Brigade of Guards dressed in civilian clothing marching in a ceremonial parade (1958). © D.R.
London-inspired pinstripe Brioni suit, consisting of a short fitted overcoat with velvet collar and cuffs, and trousers (1968). Hat made by Panizza. © Brioni Archives.

Pattern for a suit designed for Robert Wagner. © Brioni Archives.
Interior side of a jacket, half finished, with the traditional linen lining and basted stitching. © Brioni Archives.

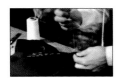

Workmanship on the reverse side of a tuxedo, the first phase in a series of more than 5,000 hand-sewn stitches, guaranteeing a perfect suit. © Brioni Archives.

Drawings for the "Celanese" Collection (1963-1964). © Brioni Archives.

His Majesty the Maharaja of Sahana with members of the royal family (1916). © Hulton Getty/Fotogram-Stone Images.
One of the "Maharaja" style designs that were very popular in Swinging London in the 1960s, during the hippy era when oriental philosophy and treks to Katmandu were fashionable. Absent from menswear since the end of the eighteenth century, gold and silver came back into style. © Brioni Archives.

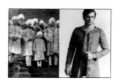

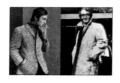

Cognac-colored astrakhan jacket with leather details (from the end of the 1960s). © Brioni Archives.
Peter Sellers, wearing a Brioni coat in light-colored astrakhan. © Brioni Archives.

Outfit in large check, consisting of a cape and trousers (from the beginning of the 1960s). © Brioni Archives.
A lace shirt and bowtie (from the end of the 1960s). © Brioni Archives.

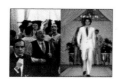

Gaetano Savini surrounded by his models, backstage during a fashion show. © Brioni Archives.
Brioni fashion show, mid-1960s. © Brioni Archives.

A "space suit," consisting of a straight-cut tunic-length jacket with zipper closing, worn with pants (1970). © Brioni Archives.

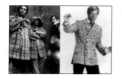

Large check duffle coats, "Criollo" design, with light-colored leather details. © Brioni Archives.
Jacquard-weave jacket with decorative topstitching (1967). © Brioni Archives.

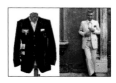

Travel jacket with sixteen pockets, custom-designed for a California client (1968). © Brioni Archives.
The writer Gay Talese in a Brioni three-piece suit, in the 1970s. © Brioni Archives.

Hand-stitched Brioni buttonholes, from the "Celanese" Collection (1963). © Brioni Archives.
Prince Raimondo Orsini, dressed in Brioni, at the ruins of the Roman Forum (1982). © Hulton Getty/Fotogram-Stone Images.

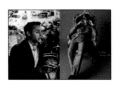

A professor and his students, at the Brioni School of Tailoring which opened in Penne in 1980. © Brioni Archives.
Double-breasted cashmere overcoat, in herringbone (1947). © Brioni Archives.

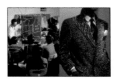

Three-button wool suit, in herringbone. Cotton voile shirt made by Burini (part of the Brioni Group). © Brioni Archives.
Italy in the 1950s: paparazzi. © The New Roma Press Photo.

The Italian *dolce vita*. The actor Sal Mineo, discovered in the film *Rebel Without a Cause* (1955), at the Café de Paris, in Rome, in July 1960. © The New Roma Press Photo.
Three-button Brioni suit in flannel. Cotton voile shirt by Burini. © Brioni Archives.

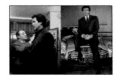

Checchino Fonticoli, Brioni's master tailor, creating a suit for Pierce Brosnan, in the Rome workshop (1995). © Brioni Archives.
Pierce Brosnan in three-piece Brioni suit, during the press conference given before the filming of *GoldenEye*, at the Leavesdon Studio (England), in January 1995. © Eon Production Archives.

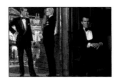

Brioni tuxedos. Drawings by Luigi Tarquini. © Brioni Archives.
Pierce Brosnan in a hand-tailored tuxedo, with peak satin lapels and double-breasted low-cut waistcoat, in midnight blue wool, worn in the 1997 James Bond release, *Tomorrow Never Dies*. © Brioni Archives, photo: John Stoddart.

The author would like to thank Bernard Simeone for his invaluable contribution.

The publishers would like to thank the House of Brioni and in particular Umberto Angeloni and Antonella De Simone, for their assistance in producing this book. We also wish to thank Edward Dzern, John Stoddart, Slim Aarons, and Florence Briand (Hulton Getty/Fotogram-Stone Images).

BOSTON PUBLIC LIBRARY

3 9999 03723 546 0

Boston Public Library

The Date Due Card in the pocket indicates the date on or before which this book should be returned to the Library.

Please do not remove cards from this pocket.